Matthew Hilton: Furniture for our time

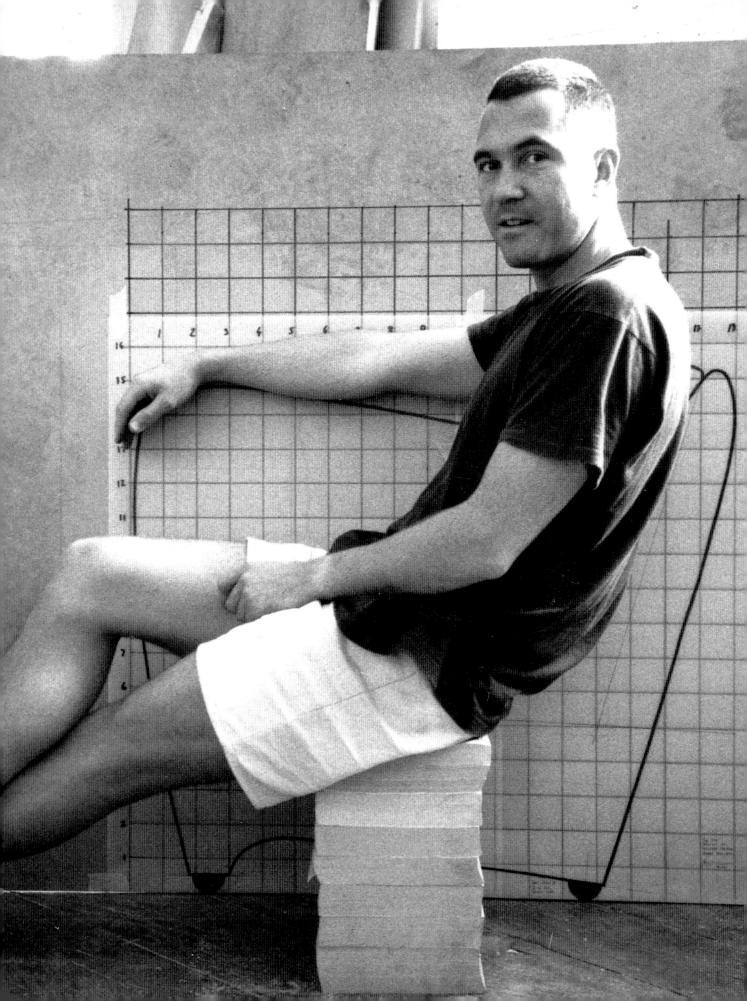